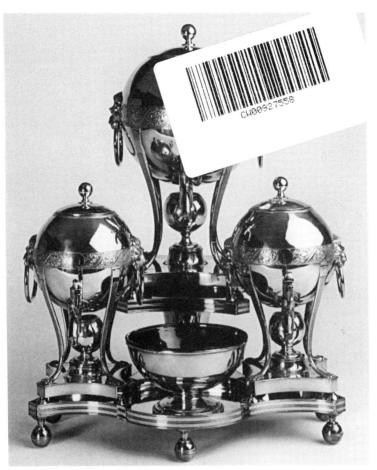

Tea and coffee machine, about 1800. The central hot-water urn can swivel to replenish the flanking urns. Standing 1 foot 11½ inches (60 cm) high, this was a costly item.

OLD SHEFFIELD PLATE

Anneke Bambery

Shire Publications Ltd

CONTENTS

Introduction 3
Manufacturing methods 5
The eighteenth century 13
The nineteenth century and after 23
Identifying Old Sheffield Plate 28
Care and cleaning 31
Further reading 32
Places to visit 32

Printed in Great Britain by C.I. Thomas & Sons (Haverfordwest) Ltd, Press Buildings, Merlins Bridge, Haverfordwest, Dyfed SA61 1XF.

British Library Cataloguing in Publication Data: Bambery, Anneke. Old Sheffield Plate. 1. Fusion-plated Sheffield silverware. I. Title. 739. 2' 3742821. ISBN 0-85263-965-1.

ACKNOWLEDGEMENTS
The author wishes to thank the Archives Department, Birmingham Reference Library; the Bowes Museum, Barnard Castle; Miss Helen Clifford, Victoria and Albert Museum RCA course; J. W. Northend Limited; Sheffield City Museums; the Director of Libraries and Information Services, Sheffield; Samuel Taylor Limited; Ms K. A. Thorpe; and the private owners who have helped with the preparation of this book. She is particularly grateful to Miss M. A. Pearce and Mr D. E. Sier for their assistance, and to Mr Sier for many of the photographs. Illustrations are acknowledged as follows: Bowes Museum, Barnard Castle, page 16 (upper); from A History of Old Sheffield Plate published by J. W. Northend Limited, Sheffield, pages 6 (right), 7, 8, 14 (right); private collection, pages 15 (lower), 16 (lower), 19 (left), 21 (lower), 25 (lower right); Samuel Taylor Limited, Redditch, page 6 (left); Sheffield Record Office, pages 5, 18 (lower). All other illustrations are from the collections of Sheffield City Museums.

Cover: *An unmarked Old Sheffield Plate inkstand, about 1815.*

Below: *A set of 21 fused-plate counters with their copper-gilt box, early nineteenth century, by Edward Thomason, Birmingham. Each counter bears a different observation on playing whist, taken from Thomas Mathews's book of 1804.*

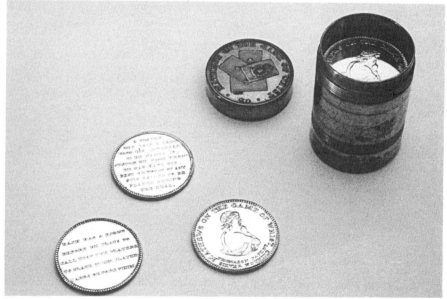

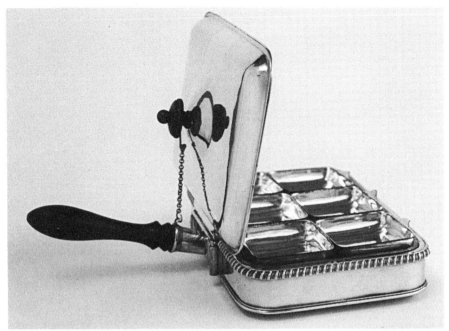

Cheese-toasting dish, about 1810. The curved lid, suspended by a chain, reflects firelight and heat on to the cheese in the trays, whilst hot water in the dish itself warms the trays from below.

INTRODUCTION

Silver plating means applying a thin layer of silver to the surface of a cheaper material, and articles made from a silver-plated base metal can look as if they are made of solid silver, while costing less. Over the centuries various silver-plating techniques have been developed, and one of them, the process known as fusion plating, produced the silver-plated ware now called Old Sheffield Plate or fused plate. It is its method of production which distinguishes Old Sheffield Plate from other types of silver-plated wares.

The fused-plate trade was established in Sheffield around 1742 and thrived for about a hundred years, until it was superseded by electroplating after 1840. When it was introduced, fusion plating offered considerable advantages over the existing methods of silver plating, all of which involved applying silver by hand to individual base-metal articles. Fusion plating, by contrast, was a process whereby a block of base metal was silver-plated, rolled into sheet form and then used for the manufacture of articles: in almost all other plating methods the article is made up in the base metal before being silver-plated. Fusion plating made the large-scale production of silver-plated goods a possibility.

The fused-plate manufacturers nearly always used copper as the base metal, and pieces of fused plate often show characteristic patches of red-brown where the silver has worn away, revealing the copper beneath.

Fusion plating became a major industry in Sheffield, but it soon spread to other centres, chiefly Birmingham and towns in Europe. The trade did not entirely die out when electroplating was introduced but was retained for a few specific products.

3

A sheet of sterling silver was placed on the face of a copper ingot. The inner surfaces of both metals had previously been scraped to make them absolutely clean.

A sheet of copper, the inner surface whitewashed to prevent its fusion with the silver, was placed over the silver sheet to protect it in the furnace. The three layers were bound together.

When the block came out of the furnace the binding wires were cut and the copper sheet was removed. The silver was then fused to the copper ingot.

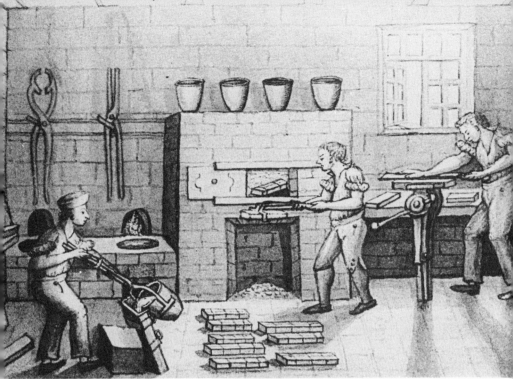

A workshop, about 1830. In the centre a workman is loading the plating furnace. The man on the left is casting copper ingots, whilst the third man is planing the face of a cooled ingot to make it smooth.

MANUFACTURING METHODS

To make the sheet of silver-plated metal out of which articles would be made, the workman took an ingot made from copper alloyed with about 5 per cent zinc and measuring roughly 9 inches (23 cm) long, 2½ inches (6.5 cm) wide and 1½ inches (4 cm) thick. He planed its upper surface and placed upon it a sheet of sterling standard silver. The thickness of the silver depended on the manufacturer's requirements, but a gauge of ⅛ inch (3 mm) on an ingot of the above dimensions would give very good-quality fused plate.

A heavy steel block called a *bedder* was next positioned on the silver and was repeatedly struck with a 28 pound (12.7 kg) hammer, bringing the silver and copper into close contact. The workman then placed on the silver a protective copper sheet about ⅛ inch (3 mm) thick, whitewashed on its inner surface to pre-

vent it from fusing with the silver. The three layers were tightly bound with iron wire and a paste of ground borax was applied around the side of the block at the junction of the silver and the copper ingot. This acted as a flux, melting at a low temperature and excluding air which might oxidise the two metals and prevent their union.

The block was then put into the furnace. After about twenty minutes the workman, watching through a sight hole in the door, would see the silver glisten as it began to melt. Using tongs, he carefully withdrew the block. The iron wires and the copper sheet were removed to reveal the silver, now united with the copper ingot. The adjoining surfaces of the two metals had fused; this happened because an alloy of silver and copper formed readily where the surfaces met. The melting point of the

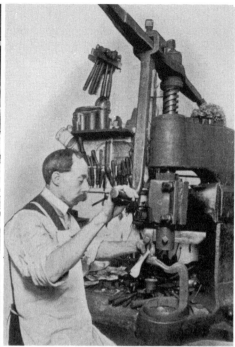

Left: *After cooling and cleaning, the fused block was rolled into sheet. Here fused plate is going through a modern electrically powered rolling mill at Samuel Taylor Limited, Redditch, in 1987.*

Right: *A fly-press in use around 1900. Such hand-operated presses were probably used by the earliest Sheffield platers when making articles from fused-plate sheet.*

alloy is lower than that of the silver or copper, so the two metals retained their integrity whilst their adjacent surfaces melted and fused.

The process described here would result in silver plating on one side only, called single plate. Double plate was made by fusing silver to both upper and lower surfaces of the ingot.

After cooling and cleaning, the fused block was *cold-rolled* into sheet metal by passing it repeatedly through powered iron rolls to reduce its thickness. At intervals during rolling, and during subsequent manufacturing processes, the metal had to be annealed, to rid it of the effects of work hardening, by heating and then cooling it. Because the silver and copper expanded equally when rolled or worked, fused plate behaved as a homogeneous material.

In the next stage of manufacture the sheet metal was fashioned into goods. The earliest fused-plate products are likely to have been small and were probably made using the *fly-press,* a hand-operated machine which forces sheet metal into a concave die through pressure from a matching convex head. Sheffield cutlers were already using such presses to stamp metal handles for knives and mechanical production methods like this helped to make fused plate a viable alternative to silver. By using bigger presses, called *drop stamps,* the Sheffield platers were soon able to make larger objects in this way. Dies were produced by hand from steel (or sometimes cast iron) blocks. As this was skilled work and dies were expensive, firms got as much use as possible out of

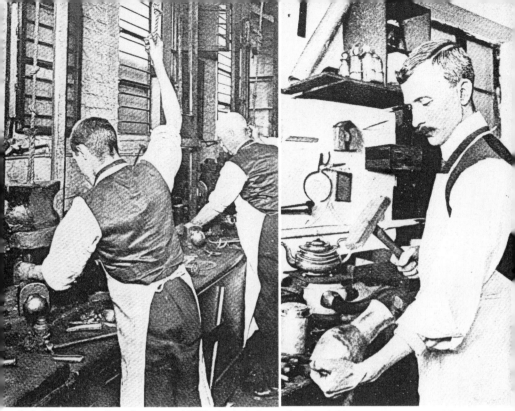

Left: *Drop stamps in action, around 1900. As the industry developed, bigger presses were used for forming fused plate. The shaped hammer-head dropped repeatedly on to the metal, forcing it into a concave steel die.*

Right: *The fused-plate workers adopted the silversmithing technique called raising, by which hammers and mallets were used to shape the metal. Hollow-ware was often made this way.*

each die. Relief decoration was sometimes incorporated into a die, but the definition of a stamping might have to be improved by hand afterwards, using chasing tools.

Stamping was not the only method of shaping fused plate. Because of the cost of dies it could be uneconomic and sometimes it was technically impossible. Many articles were made by the traditional silversmithing technique of *raising,* using mallets and hammers to work the sheet metal into shape. Raising was particularly used in making hollow-ware vessels and containers and also for large items like dish covers which would have needed enormous dies.

Around 1820 the Sheffield platers began to use another technique for shaping hollow-ware. This was *spinning,* in which a flat disc of metal was secured against a wooden pattern or mandrel on a lathe and, as the lathe rotated, the workman forced the metal over the mandrel using a burnisher.

Most articles were assembled from a number of components, and the various components were often formed by different methods. An eighteenth-century coffee pot, for example, might have a raised body, whilst the spout, finial and handle terminals were usually stamped in two halves. All these parts had to be assembled by soldering and soft solder, a mixture of lead and tin, was commonly used. Hard solder, a compound of brass and silver, was also employed, for example in constructional seams in the body. Components like ball feet and finials, which had to be solid, were filled with soft

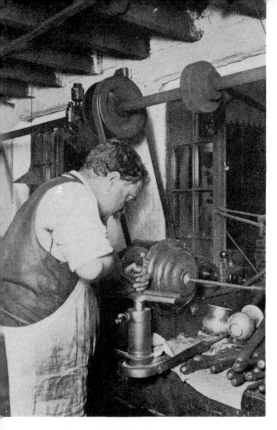

Around 1820 steam-powered spinning lathes were introduced to Sheffield. The fused-plate sheet was worked up over a shaped wooden pattern as it spun on the lathe.

thin silver, filled with soft solder and then applied to the body of the piece. Such mounts had been made from fused plate since the 1770s or earlier, but silver mounts had a number of advantages. They provided relief decoration of a depth that was difficult to achieve in fused plate without risking cracks in the silver skin; when they got worn, as high relief quickly does, they revealed the silvery-grey solder filling, not copper; and when an applied mount occurred at the rim of an article, for example a salver, the border of a silver mount could be lapped over to conceal the copper core.

Many different decorative techniques were used. As mentioned earlier, relief decoration could be achieved by stamping, but sometimes a traditional silversmithing method was employed and relief ornament was often *repoussé* work, executed with hammers and chasing tools. For some types of decoration the standard silversmithing technique could not be applied. Pierced decoration, popular in the 1770s and 1780s, was carried out in silver by means of a small saw. This left ragged edges which, if filed, would badly expose the copper core, so the Sheffield platers turned to the *fly punch*. This hand-operated device pierced the metal with such force that the silver surface was dragged down into the hole, covering the copper core.

Engraved decoration was also a problem, for the copper core was easily exposed and as far as possible the fused-plate workers substituted *flat chasing,* a technique whereby the pattern is indented and no metal is removed. But customers liked to have their monogram, crest or coat of arms engraved on their silver and plated tablewares, so the fused-plate manufacturers had to provide a spot on the article where this could be done without causing damage. Towards the end of the eighteenth century some pieces were mounted with shields or bands of either silver or more heavily plated copper which were soldered on to the body in the place where engraving was required. During the

solder. Many tall pieces of hollow-ware were formed from a flat sheet hammered into a cylinder, which was soldered along the vertical seam. A base was then soldered in and the article was further shaped by raising.

A major difficulty with fused plate was its copper core, which showed at every raw edge. The Sheffield platers devised several techniques to conceal this, although some early pieces have rims which are not covered in any way. Other early articles have rims folded over to conceal the raw edge. When fused-plate wire was developed around 1768, it was soon being made into narrow mounts and soldered on to raw edges. The technique for making it was improved in the 1780s and was also useful for the manufacture of items like toastracks and baskets. Around 1785 manufacturers began to apply solid silver wire and mounts to rims.

By 1790 some articles were being given relief decoration which was stamped from

8

Right: *Soldered seams were usually straight, but less often dovetailed or 'cramped' seams are found. Seams were carefully disguised and they are not normally so easy to spot as the one on this goblet.*

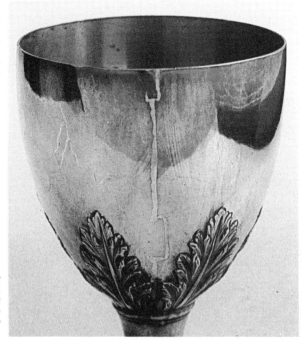

Below: *The inside of a goblet showing how the rim has been folded over. This was an early method of concealing the copper core of fused plate. It also strengthened the article.*

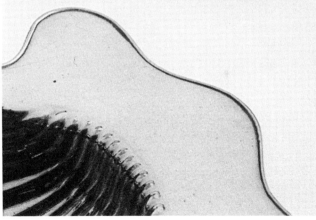

Left: *From about 1768 wire or narrow mounts of fused plate were often soldered to the raw edges of articles to hide the copper. From around 1785 silver mounts, illustrated here, were frequently used.*

9

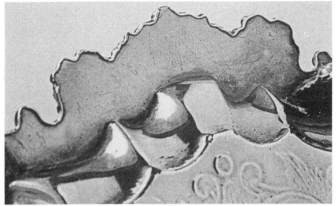

The back of a salver with a separately stamped border mount soldered to the front. The salver's copper core, exposed at the edge, has been concealed by lapping the rim of the mount over it.

Hand-sawn pierced work on an early piece. Notice the rough edges; the workman has avoided filing the holes.

Fly-punched piercing. Because a machine was used it has a repetitive character.

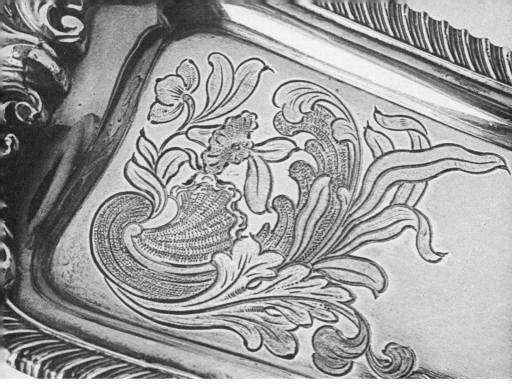

Above: *Flat-chased decoration in the centre of a snuffer tray. The pattern was indented by hand using steel punches and a hammer. The shallow indentations usually show in relief on the reverse.*

Right: *A silver shield soldered on to a tea urn to provide an area suitable for engraving a coat of arms. Pieces with this feature usually date from around 1790 to 1800.*

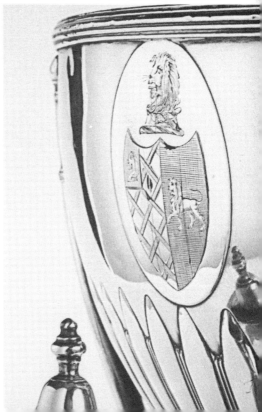

same period an alternative technique was also used, whereby a shield of more heavily plated metal was inserted into a hole cut in the body of the article and soldered into position. The front surface was generally burnished to disguise the join, but the seam is often still visible on the reverse. These 'let-in shields' were used for about twenty years before being superseded around 1810 by a new method in which the shields were now 'rubbed-in': a thin disc or rectangle of *fine* silver (silver which is as pure as the refining process allows) was positioned on the body and by means of a burnisher was rubbed under heat into the surface of the fused plate. Rubbed-in shields are much more common than let-in shields and are often seen unengraved.

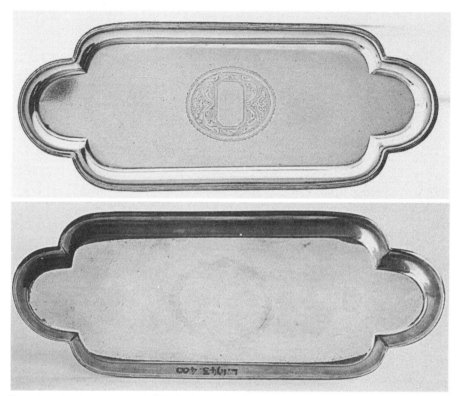

Top: *A snuffer tray with a let-in shield. A more heavily plated shield was soldered into a hole in the body and then engraved.*
Above: *The seam is visible on the reverse.*

Whenever they could, the fused-plate manufacturers used single plate to manufacture articles. Many items of hollow-ware like teapots and articles such as inkstands would most of the time have only one surface visible. Such pieces were often made of single plate, with a tinned interior or base. Tinning meant covering the copper with molten tin, which was allowed to cool, giving a surface not dissimilar to silver in colour, which protected foodstuffs from contact with the copper.

Gilding was done on fused plate from an early period. Single plate was used, and the copper surface was fire-gilded by covering it with a paste of mercury and gold, then heating it so that the mercury evaporated, leaving a layer of gold, an extremely toxic and now obsolete process.

Fused-plate articles were finished by burnishing, a method of polishing the silver surface by rubbing it with steel and agate tools dipped in soapy water. This was followed by a final polish with rouge, a powder made from ferric oxide.

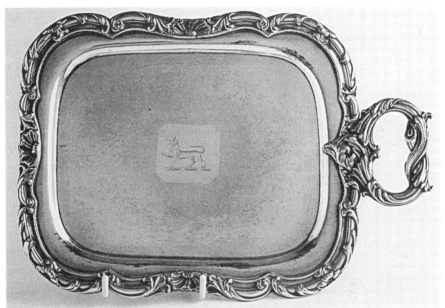

A rubbed-in shield on a nineteenth-century salver. A thin, fine silver shield was rubbed into the surface, giving an area of thicker silver suitable for an engraved crest.

THE EIGHTEENTH CENTURY

The fused-plate industry was introduced by the Sheffield cutler Thomas Boulsover, who began to make fused plate as a sideline to his cutlery business in about 1742. It is said that his first products were buttons and small boxes, for which he found a ready market. Unfortunately there are no surviving pieces of fused plate which can be attributed to Boulsover with certainty. Around 1760 he turned to new business interests, although he may not have ceased entirely to make fused plate.

The new plating industry was developed by other Sheffield cutlers who were quick to see the potential of Boulsover's invention. One of these was Joseph Hancock, who from the 1750s produced a variety of plated goods such as tea urns, coffee pots, saucepans and candlesticks. Candlesticks were made from stamped components, but hollow-ware made new technical demands. Firstly, some hollow-ware items like sauceboats displayed both surfaces of the metal, so double plate became a necessity. Secondly, in order to make hollow-ware, the artisans of Sheffield had to learn

raising techniques, skills unfamiliar in a town where cutlery was the main industry. In the 1750s and 1760s workmen were brought in from centres where raising techniques were used, such as London, York, Newcastle and Birmingham. As a result by the late 1750s the Sheffield platers were capable of making a wide range of tablewares and in the 1760s a new industry emerged in Sheffield: the silver trade, which developed as an offshoot of the fused-plate industry.

For fused plate to succeed as a cheaper substitute for solid silver it had to follow fashionable styles in silver. During the 1750s and 1760s much fused plate was made in the rococo manner, with curvilinear forms often ornamented with scrollwork in relief. In the early 1770s the Sheffield platers adopted neo-classicism, a style whose forms and ornament were inspired by the work of Robert Adam and contemporary designers. In the 1770s and 1780s much decoration was executed in relief and pierced work was also fashionable. Pierced vessels, like salt cellars, fre-

13

Right: *Thomas Boulsover of Sheffield, 1705-88, the founder of the fused-plate industry. Boulsover worked as a cutler before he introduced the trade which became so important to Sheffield.*

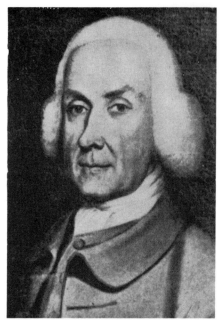

Below: *Table candlestick, about 1760, by Joseph Hancock, Sheffield. This is assembled from components die-stamped from single plate. In style it is typical of fused-plate candlesticks of this period.*

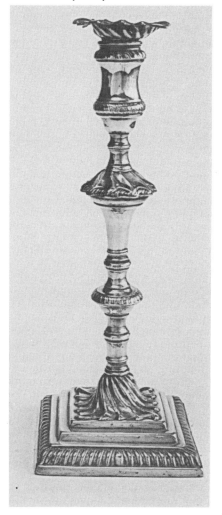

quently had blue glass liners, as did some of the wirework baskets which became fashionable towards the end of the century. Plain or beaded mounts were often applied to the rims of articles, and from the 1780s onwards reeded mounts were popular too. Fused plate was sometimes decorated with flat chasing, but from the mid 1780s there was more use of plain or fluted surfaces. Towards the end of the century oval and 'canoe' shaped tablewares became fashionable.

Die-stamping is a mass-production technique and it brought a new approach to the design of tablewares. With a fairly limited number of dies a good range of candlesticks, for example, could be manufactured by assembling various patterns for bases, shafts and nozzles in different combinations. From the 1760s onwards many fused-plate manufacturers also made small quantities of silver goods and from the outset these wares were die-stamped whenever possible. Mass production on this scale was new in the precious metal trades and there was such a ready market for fused plate and die-stamped silver that by the 1790s London silversmiths were complaining about the competition from fused plate.

Right: *Saucepan of single plate, the interior plated to protect its contents. Engraved on the handle is 'JOSH HANCOCK SHEFFIELD'. 1750s. Throughout the fused-plate era single plate was used for saucepans.*

Below: *Bread basket, about 1777, by Tudor and Leader, Sheffield. Double plate was necessary if such articles were to imitate silver successfully, since both upper and lower surfaces were visible.*

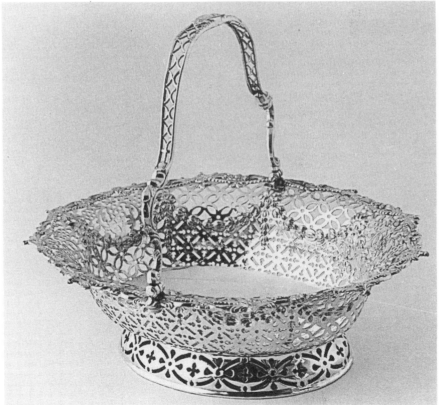

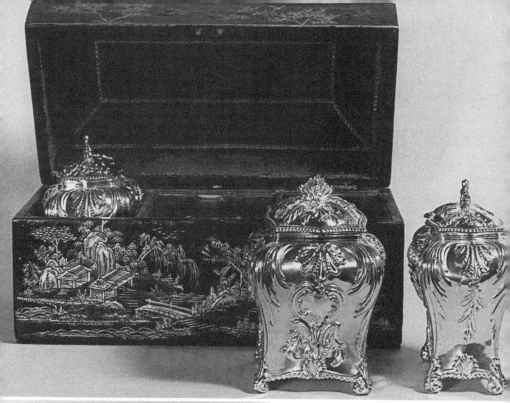

Above: *Two tea caddies and a sugar canister with their lacquered wooden box, about 1765. The caddies are made from die-stamped components and have the curvilinear outlines and scrolling ornament of the rococo style.*

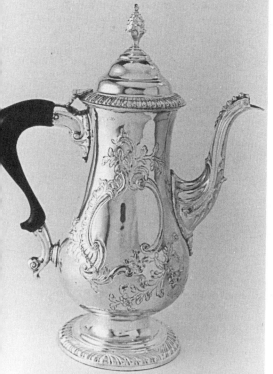

Left: *Coffee pot, about 1770, by Richard Morton, Sheffield. The raised body is decorated with repoussé work in the rococo style. The spout, finial and handle terminals are die-stamped.*

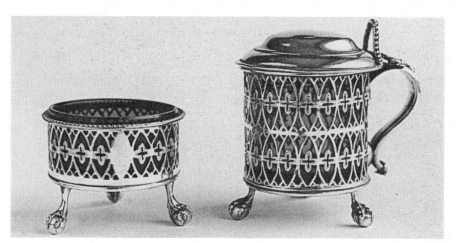

Above: *Salt cellar and mustard pot, about 1775. Pierced decoration, fashionable in the 1770s and 1780s, looked particularly attractive against blue glass liners.*
Below: *Toastrack, about 1785. Plated wire, first developed around 1768, was useful for toastracks and other tablewares such as sugar basins, which were given glass liners, bread baskets and coasters.*

Teapot, about 1785. The flat-chased decoration imitates engraved ornament on silver. Only the monogram has here been engraved; coats of arms, crests and monograms were often engraved by the retailer for the customer.

Page from Daniel Holy, Wilkinson and Company's catalogue, about 1795, showing a cruet frame with cut-glass bottles. Canoe-shaped items, like this stand, were fashionable in the 1790s.

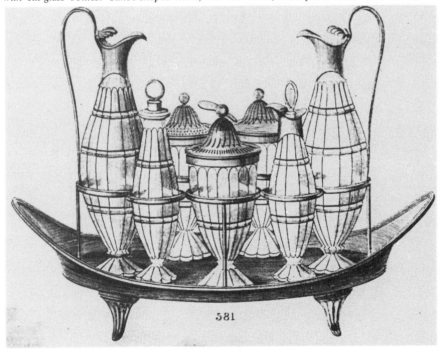

581

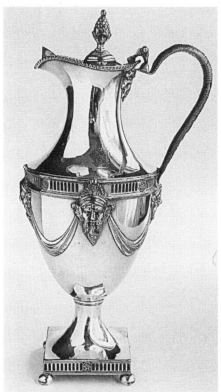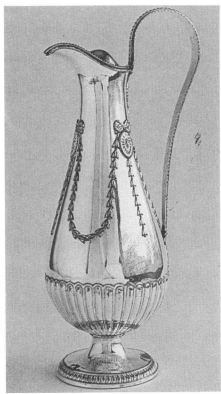

Left: *Hot-water jug, about 1776, by Richard Morton. Its urn shape and the ornamental motifs are typically neo-classical. The decoration is mostly repoussé work, but the masks are stamped solder-filled fused-plate mounts.*
Right: *Jug, about 1780, by Matthew Boulton, Birmingham. If marked, Boulton's early fused plate bore the letters BF and two crowns. From 1784 his mark was a sunburst.*

By this time the fused-plate industry had spread out from its birthplace. Possibly the first manufacturer outside Sheffield was Matthew Boulton of Birmingham, who began production at his Soho Works around 1762. His firm, which survived until 1848, made a range of domestic items and tablewares in both fused plate and silver. Probably before 1800 other firms started making fused plate in Birmingham and in the nineteenth century the trade proliferated there.

Boulton's fused plate was of high quality, and his chief rival in Sheffield was perhaps the firm of Roberts, Cadman and Company. Samuel Roberts had gained a thorough training in his father's fused-

plate factory and he combined this with an innovative approach when he went into business with George Cadman in 1784. The firm is said to have been the first to mount fused plate with silver edges and the first to apply rubbed-in shields, whilst Roberts filed numerous patents for improved products and manufacturing techniques between 1790 and 1830.

In the eighteenth century fused-plate products by Boulton and the Sheffield firms included tea and dinner wares, spoons, forks and serving implements, drinking vessels like goblets and tankards, domestic articles such as inkstands, and personal items like snuff boxes. Candlesticks were a very important product,

19

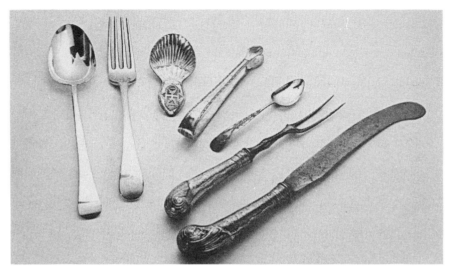

From left to right: fork and spoon, about 1800; caddy spoon, sugar tongs and teaspoon, late eighteenth century; knife and fork with rare fused-plate handles, about 1780.

Three candlesticks by Winter, Parsons and Hall, Sheffield. The central candlestick is silver, 1774; the others are fused plate, about 1780. All are made from die-stamped components assembled in different combinations.

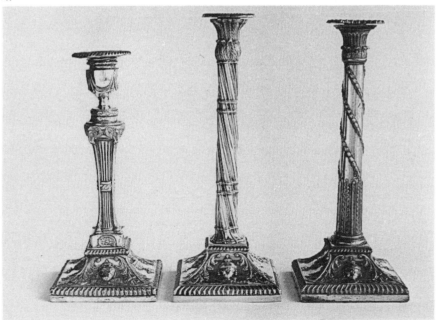

particularly in Sheffield, where one firm, Winter, Parsons and Hall, and its successor, John Parsons and Company, made little else.
Most fused plate bears no maker's mark and it can be difficult to identify the manufacturer. Unmarked pieces can sometimes be matched with solid silver items stamped from the same dies and, since the latter normally bear hallmarks, the maker can be established. Other fused-plate items may be linked with engravings in contemporary catalogues, although these are often anonymous, but attributions on the basis of a catalogue or a piece of silver should be made with caution. Many Sheffield plating businesses were run by groups of men who were partners in more

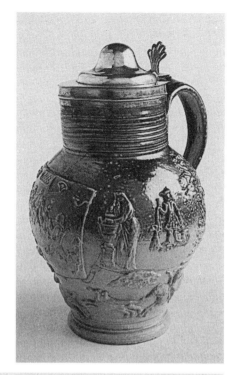

Right: *Brown stoneware jug, probably by Kishere of Mortlake, London, about 1800, with a fused-plate rim and hinged lid. Fused-plate mounts were made for glass bottles, pottery jugs and horn beakers.*

Below: *Set of engraved hunting buttons, late eighteenth century. Silver buttons were fashionable and were especially popular for huntsmen's and servants' uniforms. Fused plate made a good substitute for silver.*

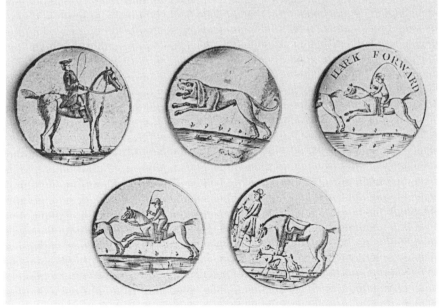

21

than one firm. These close connections encouraged the widespread practice of businesses supplying one another with components and products, and it is likely that dies were lent between related partnerships. Furthermore, when a partnership expired, its stock in trade and dies were sometimes bought by another firm. Consequently Sheffield fused plate and silver of the eighteenth century has a rather uniform character.

Manufacturers sold their fused plate chiefly through retailers. Their aim was to exploit new mechanised production methods like die-stamping, producing goods which would appeal not just to the upper classes but, more particularly, to the expanding middle classes of the eighteenth century. Fused plate, costing a quarter to a third of the price of silver, was extremely attractive to a middle-class market eager for luxury goods and many manufacturers became prosperous men.

By the 1770s fused plate was selling well throughout Britain. Most firms had a London agent and many had a London warehouse too. Fused plate was being exported to Ireland and Europe by the 1770s and a little later also to retailers in the West Indies and North America.

Some firms sent travelling agents to represent them in the United Kingdom and Europe and many issued printed catalogues from which goods could be ordered. In the nineteenth century the domestic market for fused plate remained strong, but after 1815 Sheffield's exports declined.

Group of snuff boxes: (left) stamped lid portraying Frederick the Great, third quarter of the eighteenth century; (top) tortoiseshell lid inlaid with fused-plate wire, later eighteenth century; (right) hinged lid, later eighteenth century.

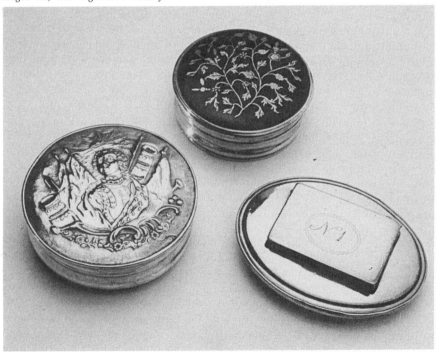

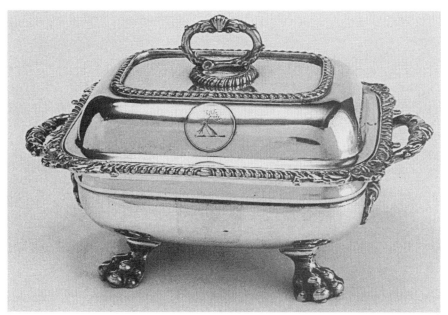

Sauce tureen, about 1815. The applied gadrooned mounts and the handles are stamped from silver and filled with solder. The feet are stamped from fused plate.

THE NINETEENTH CENTURY AND AFTER

Fashionable styles for silver and fused plate changed around 1800: forms began to display a massive quality, contrasting with the attenuated elegance of the 1790s, and a taste for rich relief decoration emerged. Fused-plate tablewares with low, swelling outlines were embellished with applied mounts of *gadrooning* (bands of small tapering ribs in relief) and *acanthus* (a stylised form of the leaves of the acanthus), and by about 1820 applied mounts, handles and feet were often richly ornamented. During the 1820s and 1830s there was a growing revival of interest in the rococo styles of the mid eighteenth century. This was reflected in fused-plate designs, along with a concurrent taste for naturalistic ornament.

In the nineteenth century fused-plate manufacturers continued to produce a great deal of everyday table and domestic wares, but they were now at the peak of their technical skill and capable of making large and prestigious pieces for the most exclusive markets. Since the end of the

eighteenth century bigger types of table-wares were being made, and soup tureens, wine coolers, table centrepieces and vegetable and entrée dishes were now often produced. Huge meat dishes with domed covers began to be made and the range of fused-plate products had become very diverse.

As in the eighteenth century, serving vessels were often fitted with a warming device; this could be a small spirit burner, or a compartment designed to contain hot water or a heated metal block. As manufacturers' skills advanced, a taste for items incorporating moving parts or ingenious fittings flourished. Telescopic candlesticks were popular from around 1795 to 1825 and in the early nineteenth century tea and coffee machines were introduced. In the 1820s and 1830s gadgets such as wine wagons and cucumber slicers were produced.

The fused-plate industry expanded in the nineteenth century: in 1825 Sheffield had around 28 firms, whilst Birmingham,

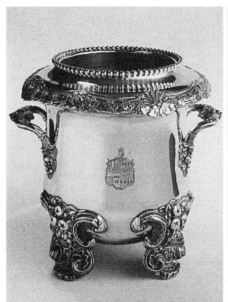 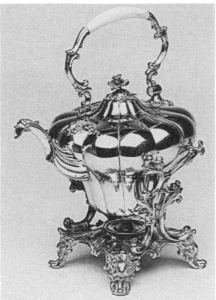

Above left: *Wine cooler, about 1820. The rim, decorated with stamped and applied silver mounts, pulls off to reveal the double walls of the vessel, which could be filled with iced water.*

Above right: *Tea kettle, about 1840, by Henry Wilkinson, Sheffield. Kettles with spirit burners provided hot water at the tea table. This example, in the revived rococo style, has a scrolling stand and naturalistic finial.*

Below: *Chamberpot and bourdalou. The chamberpot originally had a gilt interior and was probably kept in the dining room for the gentlemen. A bourdalou was a ladies' travelling chamberpot.*

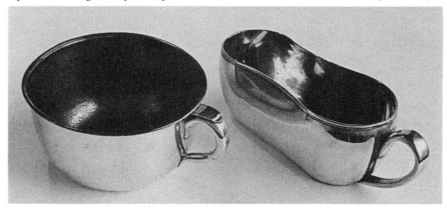

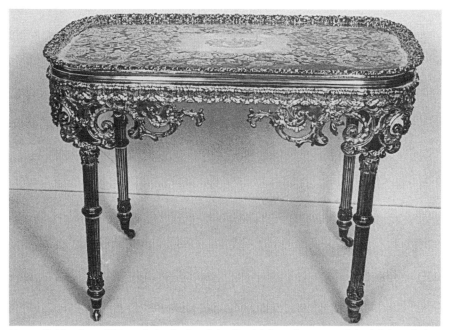

Above: *Table, about 1835, made for the Smyth family of Ashton Court, near Bristol. It is made from stamped and chased fused plate mounted on to a wooden frame and is 2 feet 6 inches (76 cm) high.*

Below left: *Soup tureen, about 1835. The bombé body and the scrolling feet recall the rococo style of the eighteenth century. There are naturalistic oak branches on the handles.*

Below right: *Badges were sometimes made in fused plate. This one, designed to be worn on the sleeve, was issued to a freeman of the Company of Watermen and Lightermen around 1805. It is mounted on to an iron backing plate.*

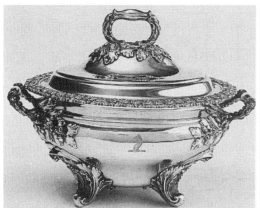

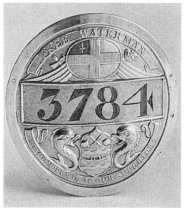

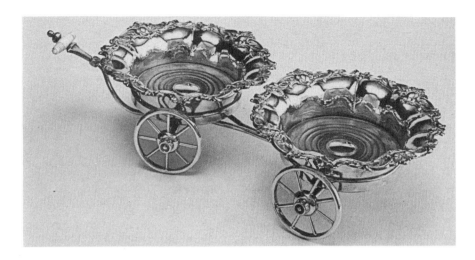

according to a writer in the 1860s, may have had about forty manufacturers during the first half of the century. Birmingham gained a reputation for the quantity of inferior fused plate it produced whereas Sheffield prided itself on high standards. Fused-plate products were also made in other British centres, for example London, but this was usually done on a small scale by jobbing workers who obtained their plated metal from Sheffield or Birmingham. In the nineteenth century the industry spread to other countries such as Sweden and Russia, although France had been making fused plate since the 1770s.

In Sheffield and Birmingham the workmen in the industry were regarded as a highly skilled class of artisan and their pay was comparatively high: towards the mid nineteenth century a good worker could earn 45 to 50 shillings a week for raising. But the Birmingham workmen were undisciplined, getting down to work only on Tuesday or Wednesday and frequently prolonging their rest breaks, whereas Samuel Roberts in the 1840s commended the steadiness and reliability of the Sheffield plating workforce. Roberts recalled in comparison the problems caused by the idle and undisciplined workers who came to Sheffield in the mid eighteenth century, attracted by the emerging plating industry. Workmen had to be very skilled and often specialised in particular processes: the braziers did raising and chasing, other

Above: *Wine wagon, about 1830. Decanters could be passed along the table on this pair of coasters on wheels. Many single coasters without wheels survive but wine wagons are not common.*

Below: *Cucumber slicer, about 1835. As the handle was turned, the blade sliced the cucumber in the tube, providing a fresh accompaniment to bread and butter at the tea table.*

workmen operated the drop stamps, some specialised in fly-punching, yet others made candlesticks, and some soldered on mounts. Women did the burnishing and polishing. Children were not employed because a full apprenticeship was necessary to acquire the requisite skills.

In 1830 Samuel Roberts took out a patent for fusion plating using a new alloy called German silver, or nickel silver. This, despite its name, contained no silver and was a mixture of copper, nickel and zinc. The first sample was brought to Sheffield in 1830 by a German named Guitike. Its light silvery-yellow colour would be much less obtrusive than copper if the silver plated upon it became worn and Roberts patented a method of fusing an intermediate layer of nickel silver between the copper and the silver. Before long he did away with the copper altogether and fused silver on to nickel silver alone. Roberts was not the only fusion plater using nickel silver as a base metal, but surviving examples of this type of fused plate are rare.

Nickel silver had a boost when electroplating was patented by Elkingtons of Birmingham in 1840. From the beginning nickel silver was the usual base metal in this technique, by which particles of precious metal are deposited by means of an electric current to form a layer upon the surface of base-metal objects. After initial difficulties electroplating quickly supplanted fusion plating for all but a few applications. The new method had several advantages: the silver could be plated very thinly; the technique required little skill in the workman; it could be carried out on the most complicated and naturalistic cast metal forms, thereby conforming to prevailing tastes; and it reduced the amount of money tied up in manufacturers' stock, because silver plating could be done at the last minute when an order came in. The consumer liked the idea that electroplating could 'restore' worn plated wares.

Many of the old plating firms went over to electroplating, but until the early twentieth century the older technique was retained for carriage-lamp reflectors, buttons and pub tankards. Fused plate had a tougher surface which withstood hard wear better than electroplate. In the early twentieth century fused plate was used as the base for enamelling when hairbrushes and hand mirrors with decorative backs became fashionable. During the Second World War the intercooler of the Rolls Royce Merlin aircraft engine was improved by the use of fused plate in its construction, and since the 1920s electrical contacts have been made from fused silver on copper. Although modern equipment is used, the manufacturing process is essentially the same today as in the eighteenth century.

Entrée dish, about 1835, by Roberts, Smith and Company, the firm founded by Samuel Roberts. It is made from fused plate with a base metal of nickel silver. Stews and ragouts were often served in entrée dishes.

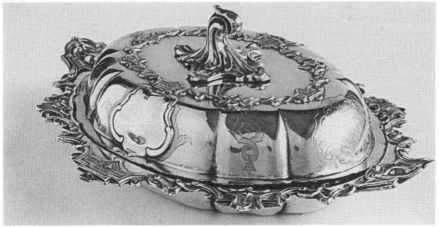

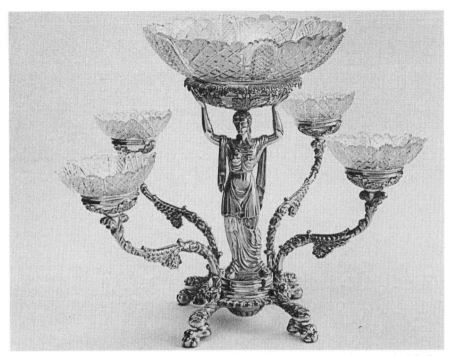

Table centrepiece, 1821, by Roberts, Cadman and Company, Sheffield. The figure is of solid silver: fused-plate articles occasionally have an odd silver component which, if hallmarked, helps to date the piece.

IDENTIFYING OLD SHEFFIELD PLATE

It can be very difficult to identify fused plate and if possible the opinion of an expert museum curator, dealer or collector should be sought. A piece should be examined while bearing in mind all the types of metalwork it might be.

If an article has a silver surface it could be solid silver, in which case a British specimen will usually have a hallmark. Alternatively the article could be silver-plated. Occasionally, however, combination pieces occur: a fused-plate article might incorporate the odd solid silver component, perhaps because the manufacturer had run out of that part in plated metal; more frequently a silver object might have its less important parts, such as the branches of a candelabrum, made from fused plate. Do not assume the whole article is silver because you see a hallmark.

The types of silver plating likely to be encountered are fused plate, close plate and electroplate. Fused plate has a number of characteristics which are described below. Close plate is silver plated on to steel and was produced from the eighteenth to the early twentieth century. It can be identified by using a magnet to detect the steel underneath the silver, but it should be noted that very occasionally fused plate is mounted on to an iron or steel backing, as in the waterman's badge illustrated.

Electroplate can be hard to identify, but it has certain characteristics which may be recognised with experience. In commercial electroplating the article is immersed in a vat and silver is deposited over its entire surface, covering all joints and seams. Therefore, if the object is in good condition but has visible seams, this may indicate that it is a piece of fused plate. However, when the silver surface of an

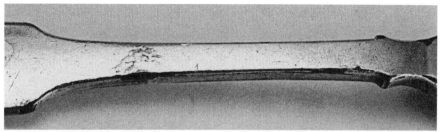

Above: *The stem of a close-plated fork. Close plate is silver plated on to steel and can be identified by using a magnet to detect the underlying steel. The silver surface tends to peel and blister.*

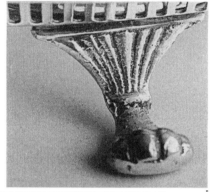

Right: *The foot of an electroplated inkstand, about 1900. Being silver on copper, and in a Georgian style, this could fool the unwary. But notice the granular surface, betraying casting: electroplated items often have cast components.*

Below: *The shaft of a candlestick with applied and solder-filled silver mounts. When such articles get worn, two contrasting colours emerge: red copper on the main body and grey solder on the mounts.*

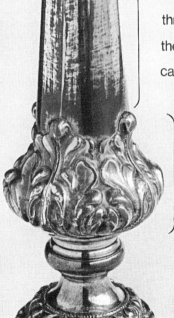

Red copper showing through the silver on the main body of a candlestick.

Grey solder showing through the silver on the applied mounts.

electroplated article gets worn, seams in the body may become visible. On the other hand, the fact that seams cannot be seen does not necessarily mean that the surface is electroplated: fused plate was so skilfully burnished that seams were often barely visible. Breathing on to fused plate helps to show up such seams.

Electroplating is often executed on cast metalwork. Cast components sometimes display a granular surface and the presence of castings is a warning signal, for fused plate, being a sheet material, cannot be cast. However, genuine pieces of fused plate like tea urns do sometimes have cast brass taps, silver-plated by another method altogether.

Since the 1840s electroplating has most frequently been carried out on nickel silver for silver-plated domestic wares. But the silvery-yellow colour of nickel silver, showing through in worn areas, does not necessarily indicate an electroplated surface, for the alloy was being used in the 1830s as a base for fusion plating. Conversely, if copper is revealed where the silver is worn away, it cannot be assumed that the piece is fused plate: in the Edwardian period silver was electroplated on to copper to make 'reproduction' Old Sheffield Plate in Georgian styles.

Beware of genuine fused-plate articles which have been electroplated after suffering wear. Electroplating diminishes the interest of such pieces and reduces their value too. Such genuine but re-plated pieces are all too common and perhaps the best indication is an unimpaired silver surface on blunted, worn relief decoration. Fused-plate articles are sometimes 'touched up' by electroplating on to localised areas of wear and this is very difficult to detect.

There are a number of features which help to identify an article as a genuine piece of fused plate. If the edges have been folded over or bear applied wire or if decorative mounts are lapped over the rims, the piece may be genuine. Silver, rather than fused-plate, mounts on the edges were considered a superior treatment and such fused plate is occasionally marked SILVER EDGES or SILVER BAGGET. The edges of electroplated items do not need to be concealed by mounts, because silver is deposited over the entire surface.

The applied and solder-filled silver mounts popular on nineteenth-century fused plate sometimes become worn, revealing the grey solder within. This contrasts with the red copper which shows in areas of wear on the main body of such pieces and demonstrates conclusively that the item is genuine. Similarly, let-in and rubbed-in shields are unique to fused plate and their presence proves that a piece is genuine. Rubbed-in shields can be detected by breathing on the article, but they are often clearly visible when the piece tarnishes, for the shield, being of fine silver, tarnishes at a different rate from the fused-silver surface which is sterling standard (a silver alloy containing at least 92.5 per cent silver). An item with a tinned interior or base is also likely to be fused plate, since tinning is not normally found on electroplate or close plate.

Makers' marks are found on a small percentage of fused-plate articles, and these can help in identification. Until 1773 there was no legislation governing the marking of fused plate and many early marks imitate silver hallmarks. In 1773 it became illegal to use marks consisting only of letters on silver-plated wares, but in 1784 it was enacted that platers might use marks which comprised the manufacturer's full name followed by a device which did not resemble a mark for solid silver. A proviso was that silver platers operating within a 100 mile (160 km) radius of Sheffield had to register their marks at Sheffield Assay Office, with the result that from 1784 many Sheffield and Birmingham platers' marks were recorded. This useful register has been published (see 'Further Reading'), but not every mark can be traced in the records. Nor is it unusual to find nineteenth-century fused-plate marks which consist only of a device and which omit the firm's name as specified in the 1784 Act of Parliament.

Normally marks on fused plate are different in character from those found on silver, electroplate or close plate, but some fused-plate firms went on using the same marks after they had abandoned fusion plating and had gone over to electroplating. Occasionally pieces of early electroplate bearing a fusion plater's mark are found.

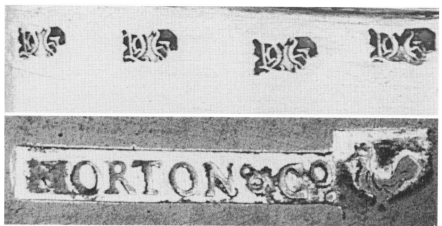

Top: *Until 1773 marks on fused plate often imitated silver hallmarks. The letters HT were used by Tudor and Leader of Sheffield. Marks consisting of letters were made illegal in 1773.*

Above: *In 1784 it was enacted that silver platers could use marks consisting of the firm's full name, followed by a device not resembling an assay office mark for silver. Richard Morton's device was a cockerel.*

Right: *Most fused plate is unmarked, but after 1784, if manufacturers did mark a piece, they often used an illegal punch. Roberts, Cadman and Company used this bell mark without stamping the firm's name.*

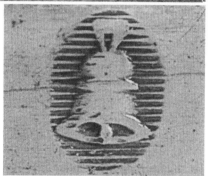

Right: *Nineteenth-century fused plate sometimes has a workman's mark. Workmen had an individual punch with which they could stamp their products; this facilitated quality control and payment for piecework.*

CARE AND CLEANING

Fused plate should be cleaned as little as possible, since cleaning inevitably causes abrasion of the silver surface. The tarnishing process is slowed down by keeping specimens wrapped in a soft duster or inside a cupboard or display case with tightly closed doors. When cleaning does become necessary, use a non-abrasive silver polish, preferably of a long-term formula, applied with a soft cloth.

Fused plate should never be 'restored' by electroplating, since this gives it a silver coating of a completely different nature. Silver polishes which deposit silver on the surface during the cleaning process should be avoided for the same reason.

FURTHER READING

Bradbury, Frederick. *The History of Old Sheffield Plate*. Macmillan, 1912. The most authoritative work on the subject. Contains a list of silver platers' marks.

Culme, John. *Nineteenth-century Silver*. Country Life Books, 1977. Has a section on Old Sheffield Plate and industrialisation.

Ryland, William. 'The Plated Wares and Electro-Plating Trades' in S. Timmins (editor), *Birmingham and Midland Hardware District*. 1866.

Sheffield City Museums. *Is It Silver?* 1988. Information sheet describing marks found on silver, plated wares and white metals and how to distinguish between them.

Veitch, Henry Newton. *Sheffield Plate, Its History, Manufacture and Art*. George Bell and Sons, 1908.

Watson, Bernard W. *Old Silver Platers and Their Marks*. Sheffield, 1908. Lists silver platers' marks registered at Sheffield Assay Office 1773 to 1836 but, unlike Bradbury, does not distinguish between fusion platers and close platers.

Frederick Bradbury's important collection of catalogues, business records and other documents is held at Sheffield City Libraries (Archives Division), Surrey Street, Sheffield S1 1XZ. Telephone: 0742 734756.

The Boulton and Watt Papers, comprising the firm's catalogues, business records and other documents, are held at the Archives Department, Birmingham Reference Library, Chamberlain Square, Birmingham B3 3HQ. Telephone: 021-235 4217.

PLACES TO VISIT

Birmingham Museum and Art Gallery, Chamberlain Square, Birmingham B3 3DH. Telephone: 021-235 2834.

The Bowes Museum, Barnard Castle, County Durham DL12 8NP. Telephone: 0833 37139.

Sheffield City Museum, Weston Park, Sheffield S10 2TP. Telephone: 0742 768588. A large and important collection incorporating the fused plate collected by Frederick Bradbury.

The Victoria and Albert Museum, Cromwell Road, South Kensington, London SW7 2RL. Telephone: 01-938 8500.

Sugar basin, about 1820, by Balaine, Paris. The copper in French fused plate is frequently redder than in British examples. This piece has been formed by spinning.

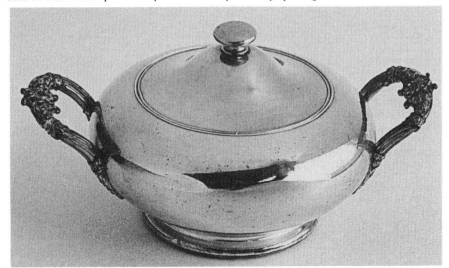